Wake Up Your Imagination

A JOURNAL FOR CREATIVE PLAY

By Jenny Ronen

CHRONICLE BOOKS
SAN FRANCISCO

ISBN 978-1-4521-6066-5

Manufactured in China

Typeset in Modum

10 9 8 7 6 5 4 3 2

Chronicle Books publishes distinctive books
and gifts. From award-winning children's titles,
bestselling cookbooks, and eclectic pop culture
to acclaimed works of art and design, stationery,
and journals, we craft publishing that's instantly
recognizable for its spirit and creativity. Enjoy our
publishing and become part of our community at
www.chroniclebooks.com.

Special quantity discounts are available to corporations
and other organizations. Contact our premiums depart-
ment at corporatesales@chroniclebooks.com or
at 1-800-759-0190.

Chronicle Books LLC
680 Second Street
San Francisco, California 94107
www.chroniclebooks.com

Are you free to play?

If you are, the whole world is happy around you. There is pure curiosity in the air, and no shadow can scare you.

This feeling is rare nowadays. Whether you are an established artist or don't consider yourself an artist at all, there is probably something that holds you back from time to time. It might be creative block, self-doubt, or fear. But in my opinion, the creative process should always remain joyful and light.

It is our responsibility to live creatively, to play rather than simply following others'—or even our own—expectations. Regardless of what you do for a living, of how busy or serious you need to be, it is important to enjoy the process of making.

Sometimes all you need is a small hint for a new beginning. You can find a lot of beginnings here. Create your own fairy tale, or get back to basics and play with shapes and colors.

This journal will also show you techniques that can lead you out of your comfort zone, where, as we all know, the real magic happens. Follow the instructions to create a repeating pattern, or merely fold a paper butterfly and let it fly away.

So grab a pencil, pick a random page, and trust your imagination to guide you. There is no right or wrong here. This journal is simply a place for you to play and experiment.

I hope these pages will inspire you to wake up your imagination and create more freely.

—Jenny

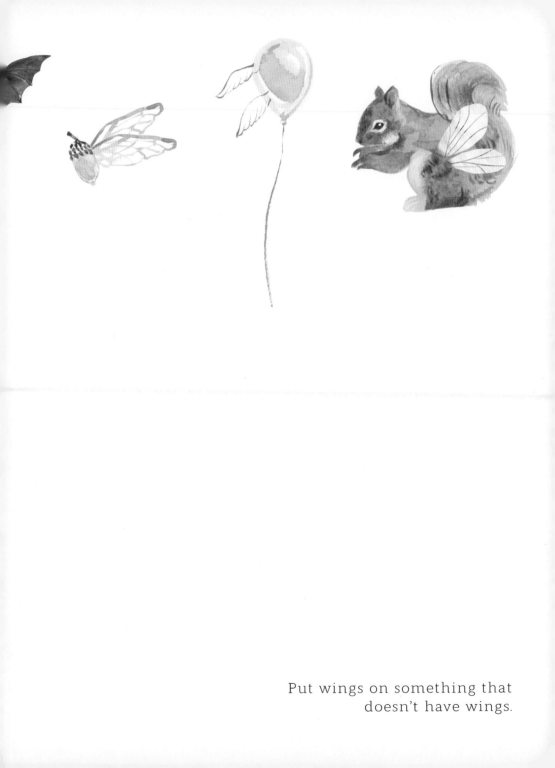

Put wings on something that
doesn't have wings.

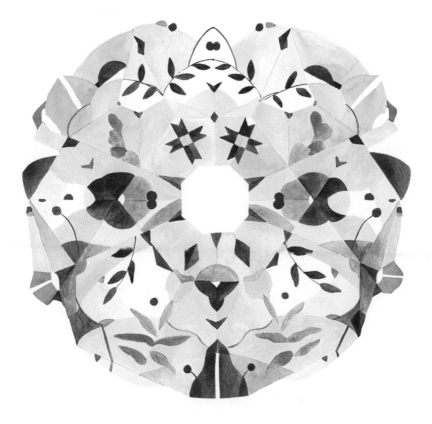

Draw something as though you were seeing
it through a kaleidoscope.

Draw like an eight-year-old.

How to cut paper snowflakes

CUT – – – – –

FOLD ——

1)

2)

3)

4)

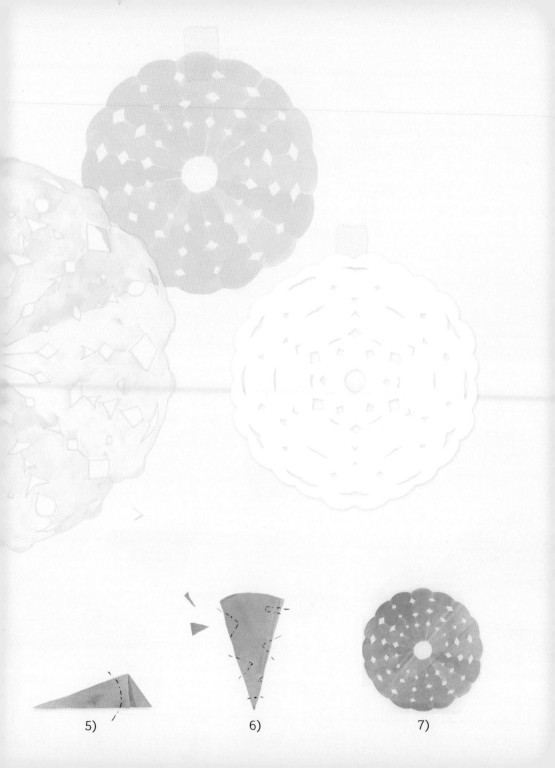

5)

6)

7)

Take a five-minute break to look at
the sky, then express what you felt,
using any medium you like.

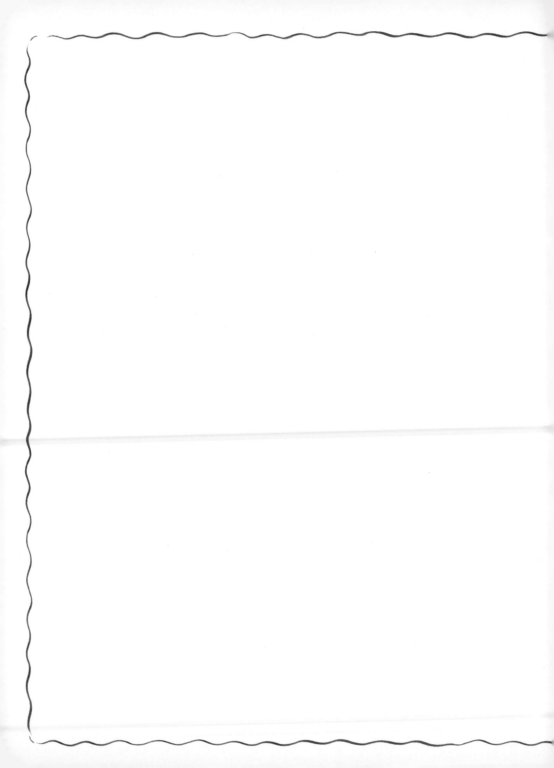

Back to basics! Play with shapes.

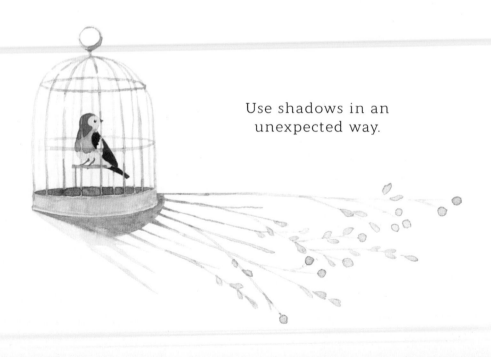

Use shadows in an
unexpected way.

Some colors don't match.
Make them love each other!

How to make a flower crown

LOOP AROUND

Look for wildflowers with flexible stems.

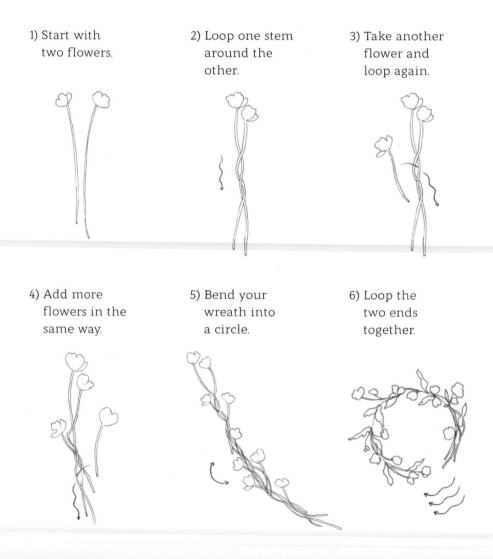

1) Start with two flowers.

2) Loop one stem around the other.

3) Take another flower and loop again.

4) Add more flowers in the same way.

5) Bend your wreath into a circle.

6) Loop the two ends together.

Don't think about an elephant.

If you could listen to a flower,
what would it say? What would the world
look like from its point of view?

Connect the dots without lifting
your hand from the paper.

How to use watercolors

1) Start by deciding where the
 white parts of the painting
 will be, then brush layers
 of paint around them, from
 light to dark.

white

1

2

3

2) Control the opacity
 of the paint by adding
 more water.

3) Try wetting the paper
 with water before paint-
 ing and then letting the
 paint "run" within that
 area.

4) Use white gouache
 paint to add small
 white details.

5) Let each layer of
 paint dry before
 adding a new
 layer.

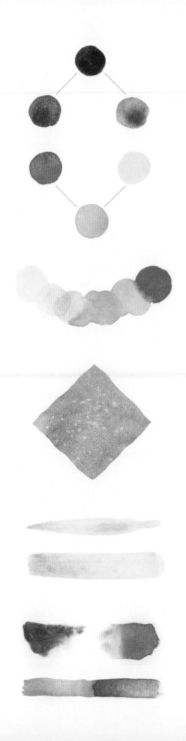

Mix colors together to create a new one.

Blend colors.

Spread some salt on top of wet paint to create a cool texture.

Round brush

Flat brush

Wet paper

Dry paper

Coloring page!
Let's color together.

Create something that will make you feel happy.

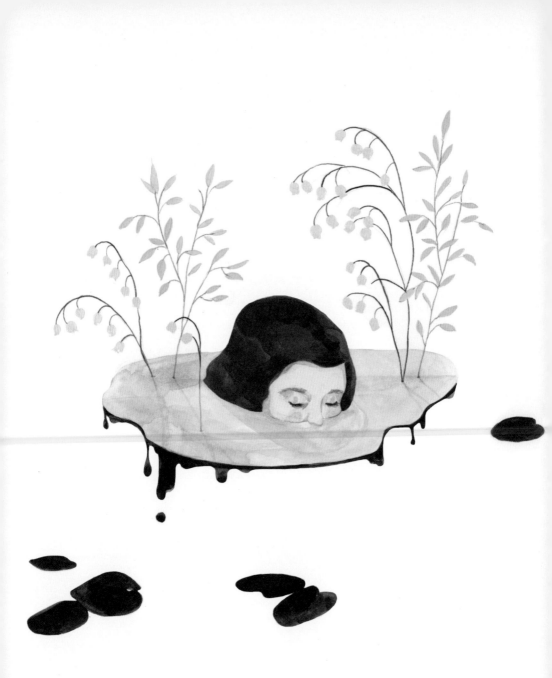

Dream . . . on paper.

How to make a repeating pattern

1) Arrange your elements on the page, making sure they don't touch the edges.

2) Cut in half vertically and swap the sides.

3) Tape the sides together and fill in the gap in the middle.

4) Cut in half horizontally and swap the sides again.

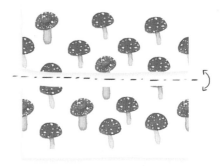

5) Tape the sides together
and fill in the gap.

6) Your pattern is ready
to be duplicated.

7) You can duplicate the repeating pattern digitally, or
manually scan and print it. You can also duplicate
the pattern by using tracing paper or a copy machine
and then tape all the copies together.

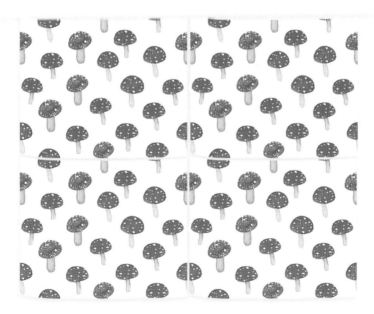

Tattoo this page.

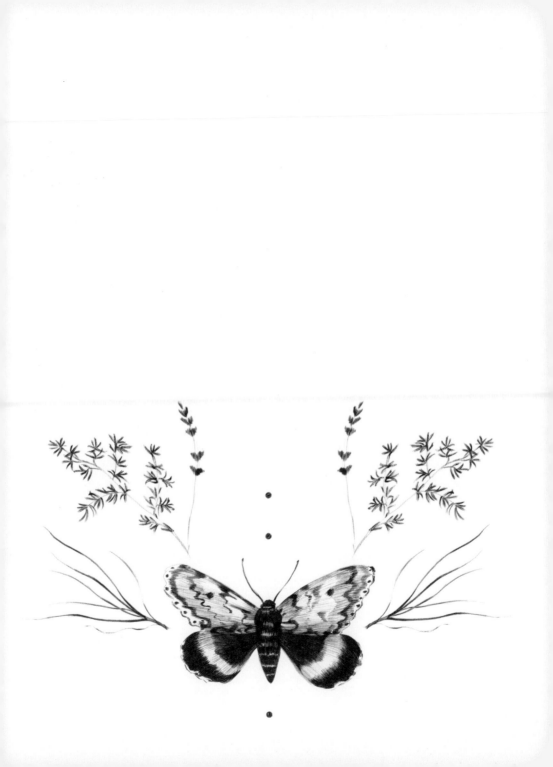

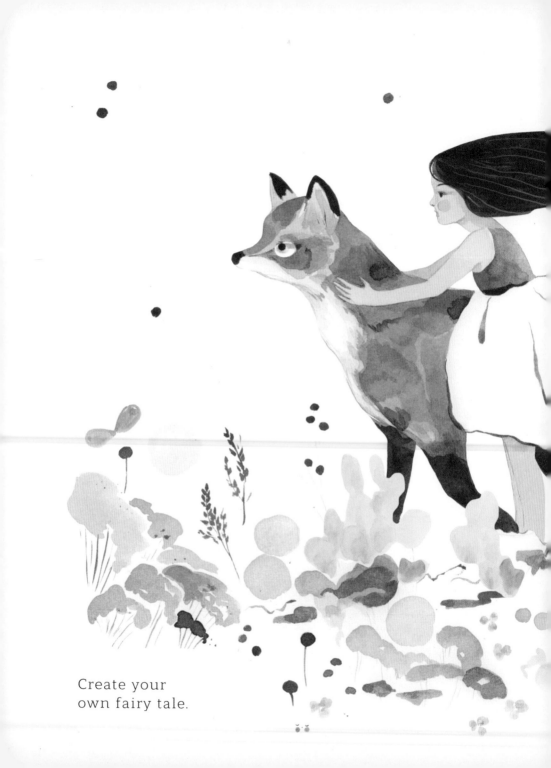

Create your
own fairy tale.

This is a private page. Illustrate a secret.

How to make your own notebook

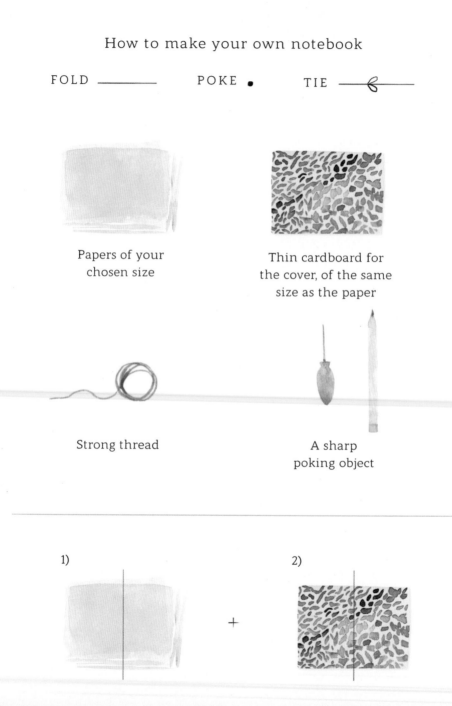

Papers of your
chosen size

Thin cardboard for
the cover, of the same
size as the paper

Strong thread

A sharp
poking object

1)

2)

+

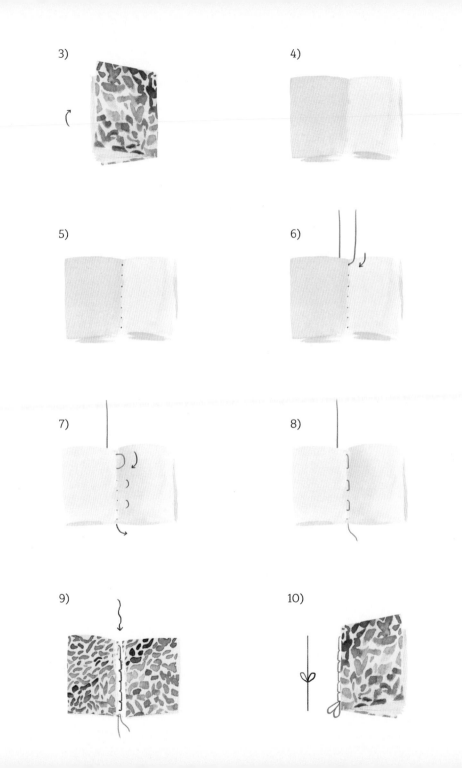

Just *cats!*

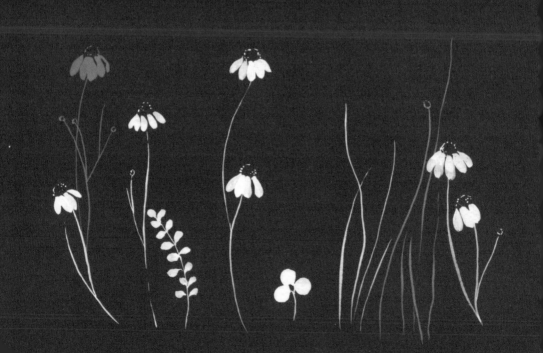

Nighttime is magic time.
Make something dark and special.

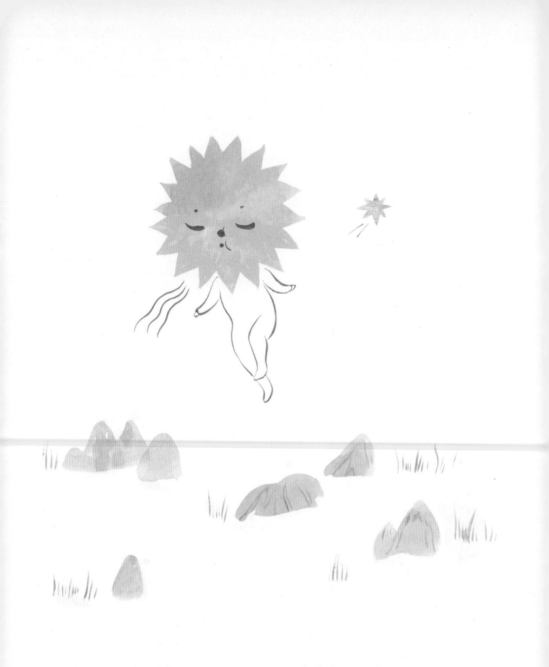

What are you grateful for today?
Draw a reminder here.

Make a collage using photos
and vintage illustrations.

What if trees could grow
from any surface?

How to make paper butterflies

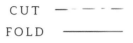

CUT — — — —
FOLD ————

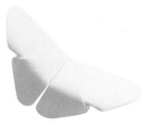

1)

2)

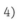

3)

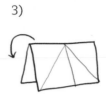

4)

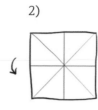

5)

6)

7)

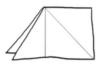

8)

9)

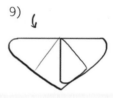

10)

11)

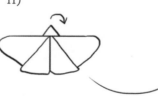
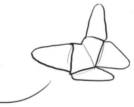

12)

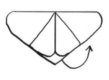

13)

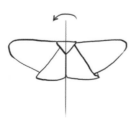

14)

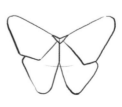

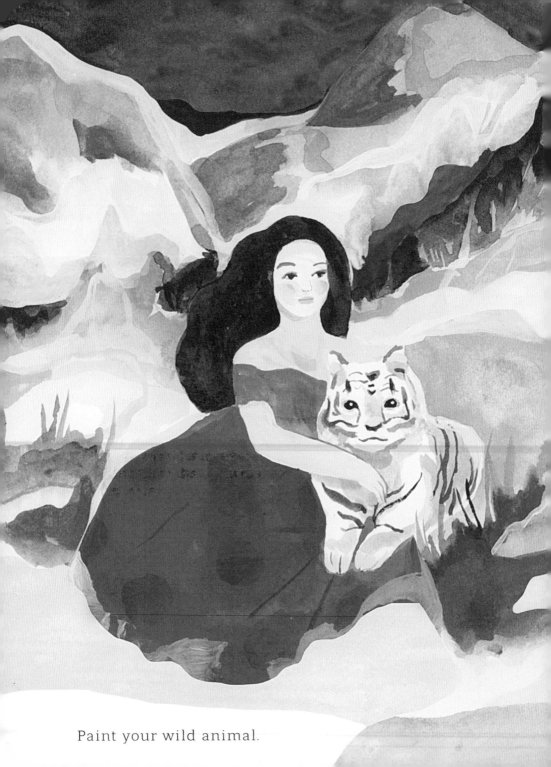

Paint your wild animal.

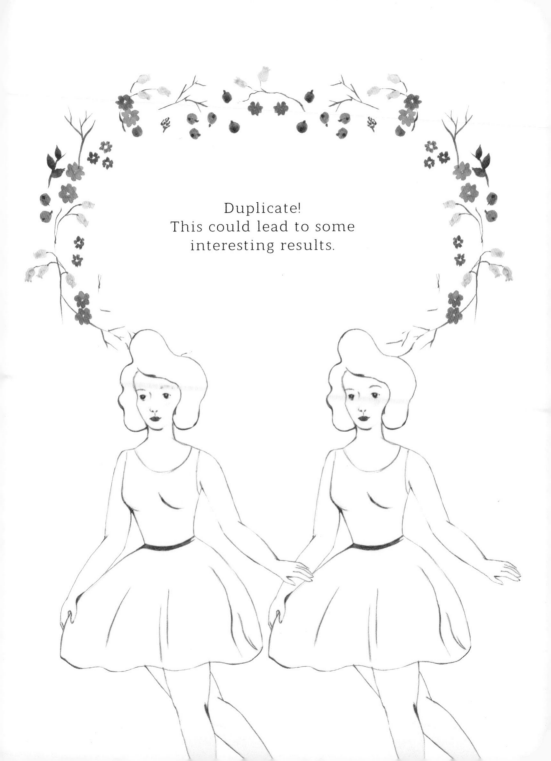

Duplicate!
This could lead to some
interesting results.

Free time!
Close your eyes and don't imagine anything.

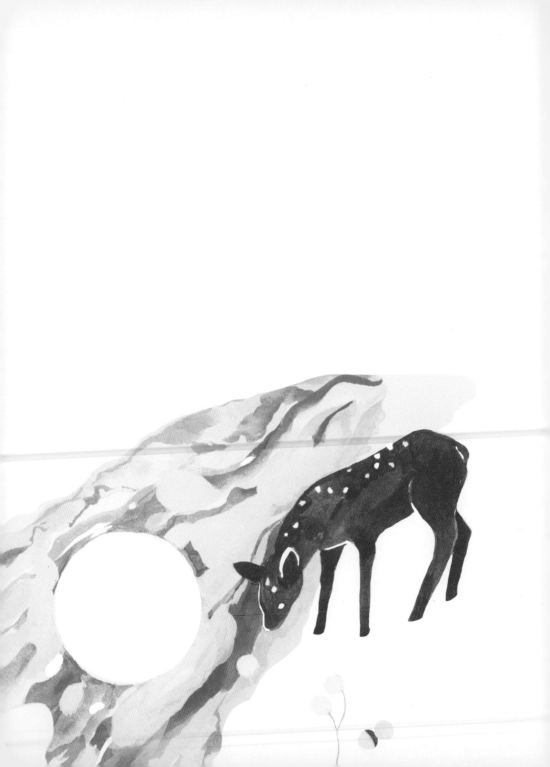

A rainbow is born when the sun touches a drop of water. What does that look like to you?

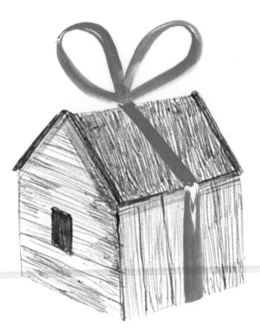

Draw something and wrap it up like a gift. →
Give this page to someone you like.

How to naturally dye fabric

100% cotton,
linen, or silk
fabric

A large pot

2 teaspoons
salt

Colorful fruit
or vegetable

A bowl

A strainer

Water

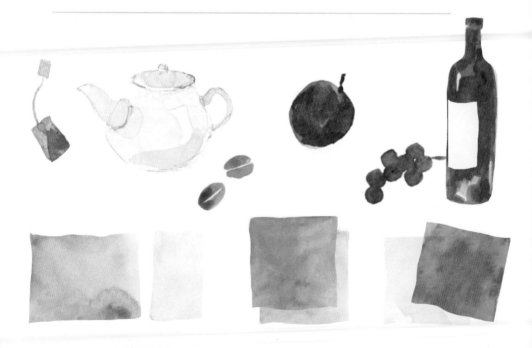

1) Fill a large pot with water and add salt and the colorful fruit or vegetable you've chosen.

2) Bring to a boil, then reduce the heat and simmer for an hour, or until the dye is as rich as you want it. Remove the fruit or vegetable from the dye using a strainer.

3) Meanwhile, fill a bowl with hot water and place your fabric in it to soak.

4) When the dye is ready, remove the fabric from the bowl and squeeze out the excess water.

5) Place your fabric in the dye and bring to a boil again.

6) Reduce the heat and simmer for at least 30 minutes and up to 3 hours, until your fabric is a bit darker than you want; when it dries, it will be a little lighter.

7) Take the fabric out and rinse in cold water, then hang dry.

*To get darker colors, use more fruit or vegetables and less water, and simmer for a longer time.

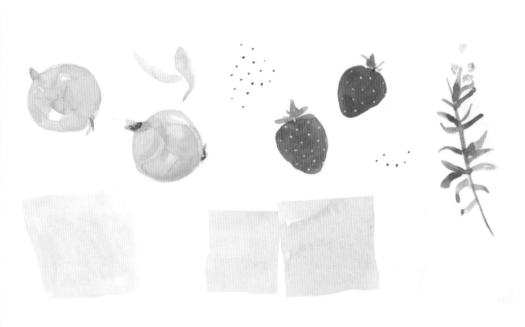

We all have our own song.
Try to illustrate yours.

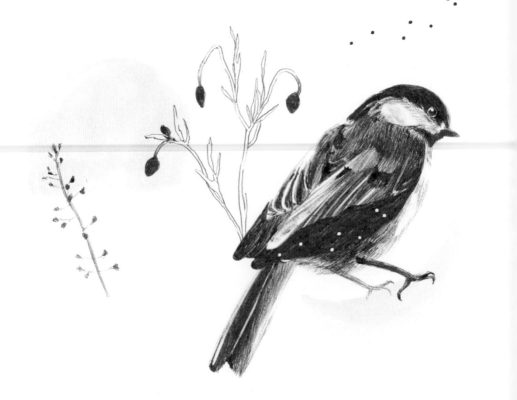

Change the laws of nature.

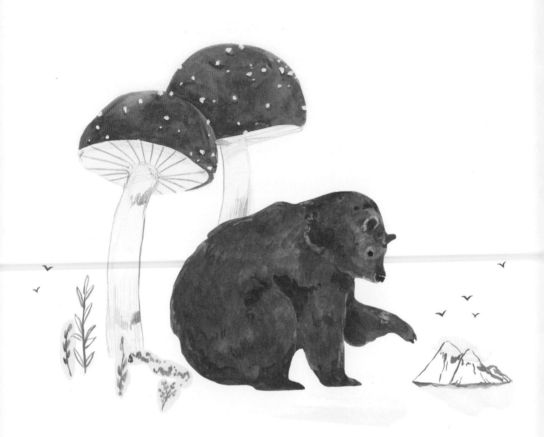

Look at the stars and draw a wish.

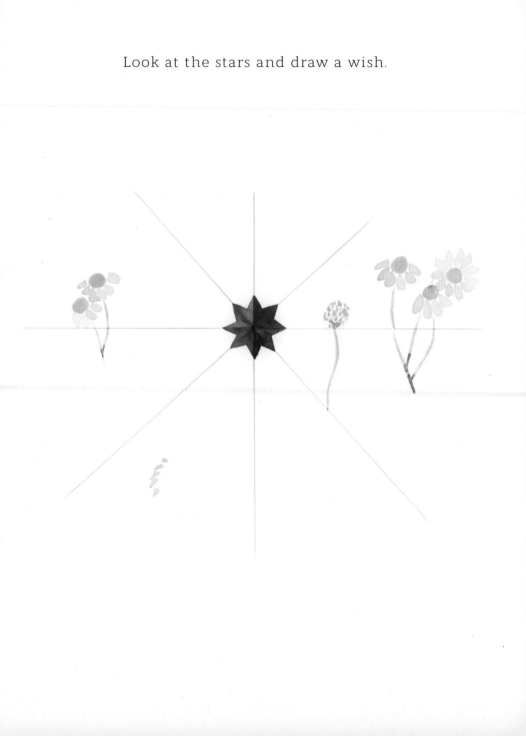

Make an illustration inspired
by your favorite quote.

"And can all the flowers talk?"

—Lewis Carroll, *Through the Looking-Glass, and What Alice Found There*

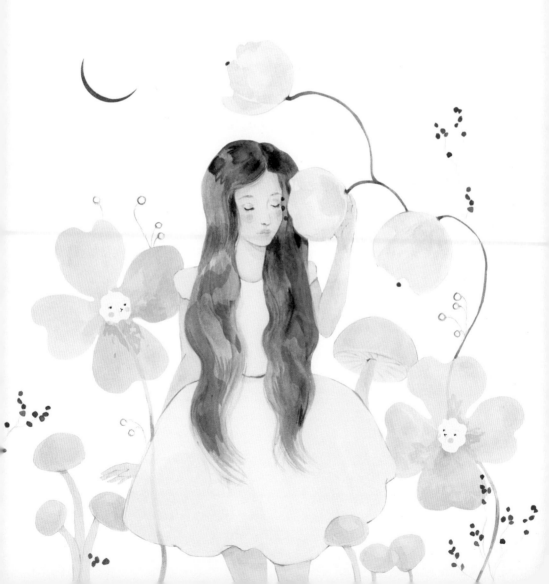

How to make a pom-pom

CUT — - — - — TIE

YARN A FORK
*Or you can use
your fingers instead

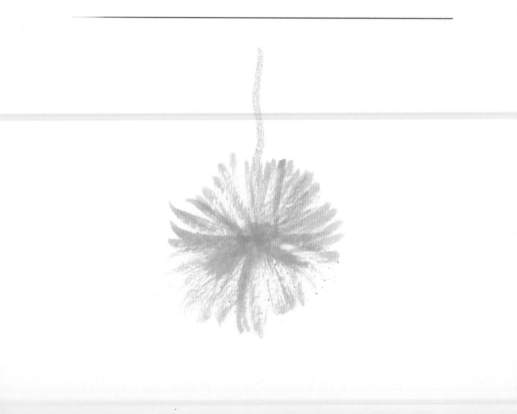

1) Cut a piece of yarn.

2) Fold the yarn and place between the tines of the fork.

3) Take another piece of yarn and wind it around.

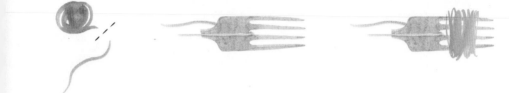

4) When nice and full, cut the yarn.

5) Tie tightly using the first short piece of yarn.

6) Slide off the fork.

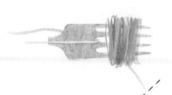

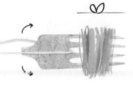

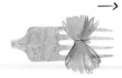

7) Cut through all the loops.

8) Trim until round and poufy.

9) Your pom-pom is ready!

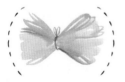

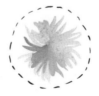

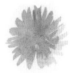